Lost In The Forest
Of Unjust Comparisons

Poetry by Reverend Joe
Photography by Emily Florence

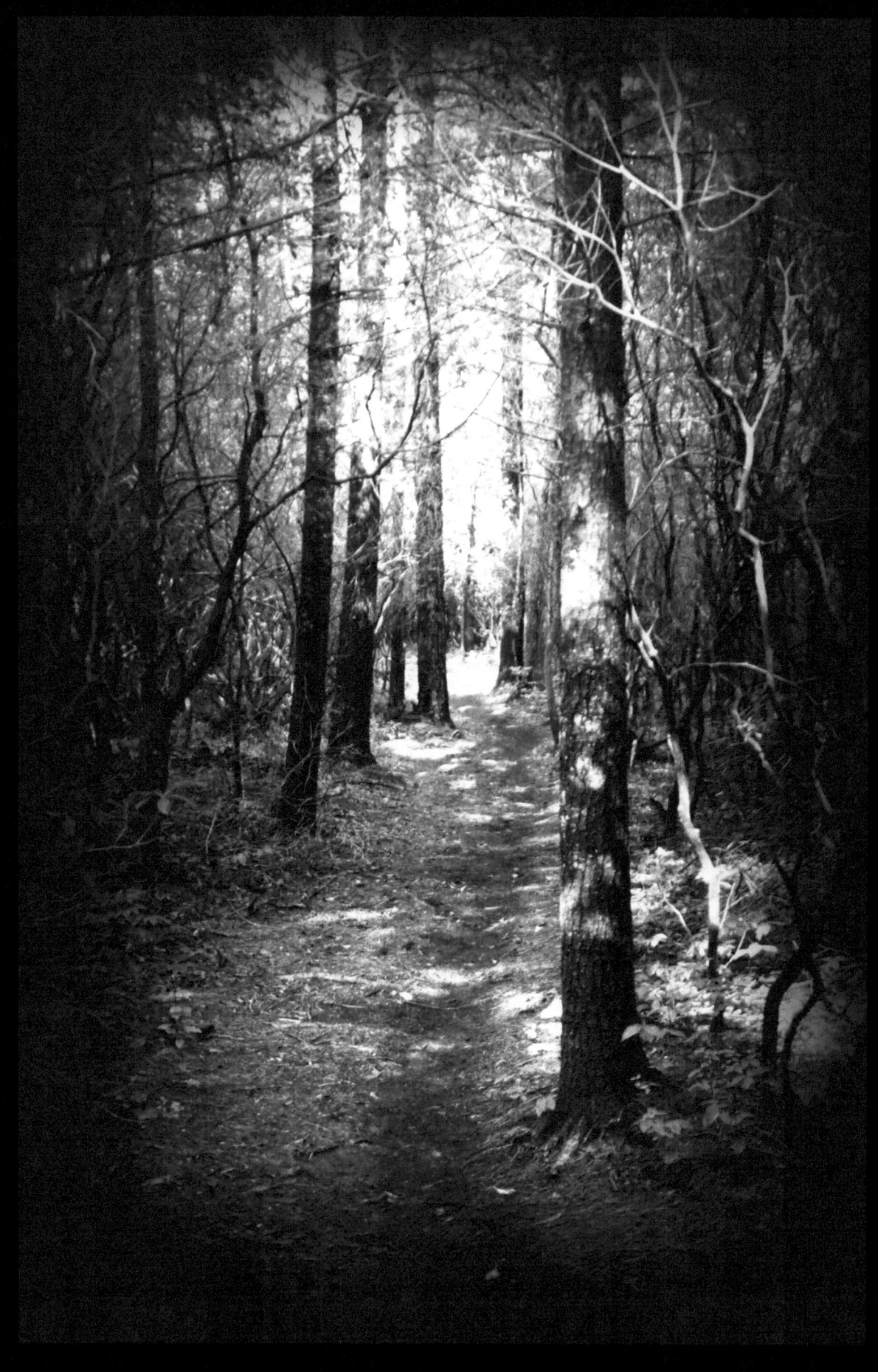

To everyone who did not believe, and those who never had a doubt- Rev Joe

For my Family, Casey, Lily Bean, my friends and teachers. For Love, and all of the beautiful unsuspecting places we find it- Emily

Copyright ©2013 by Emily Florence, Reverend Joe

Published in the United States of America

All Rights Reserved

IBSN-13: 978-1470009533

IBSN-10: 1470009536

Manufactured in the United States of America

First edition published December, 2013

Cover art and jacket design ©Emily Florence, Reverend Joe, 2013

Lost
My most
Comfortable
Place to rest
Watching my life
Disintegrate
Smiling at
The parts
I liked best
Standing outside
The lines
Til all the
Opportunities pass
Falling into
Oblivion
Happily lost
Again
At last

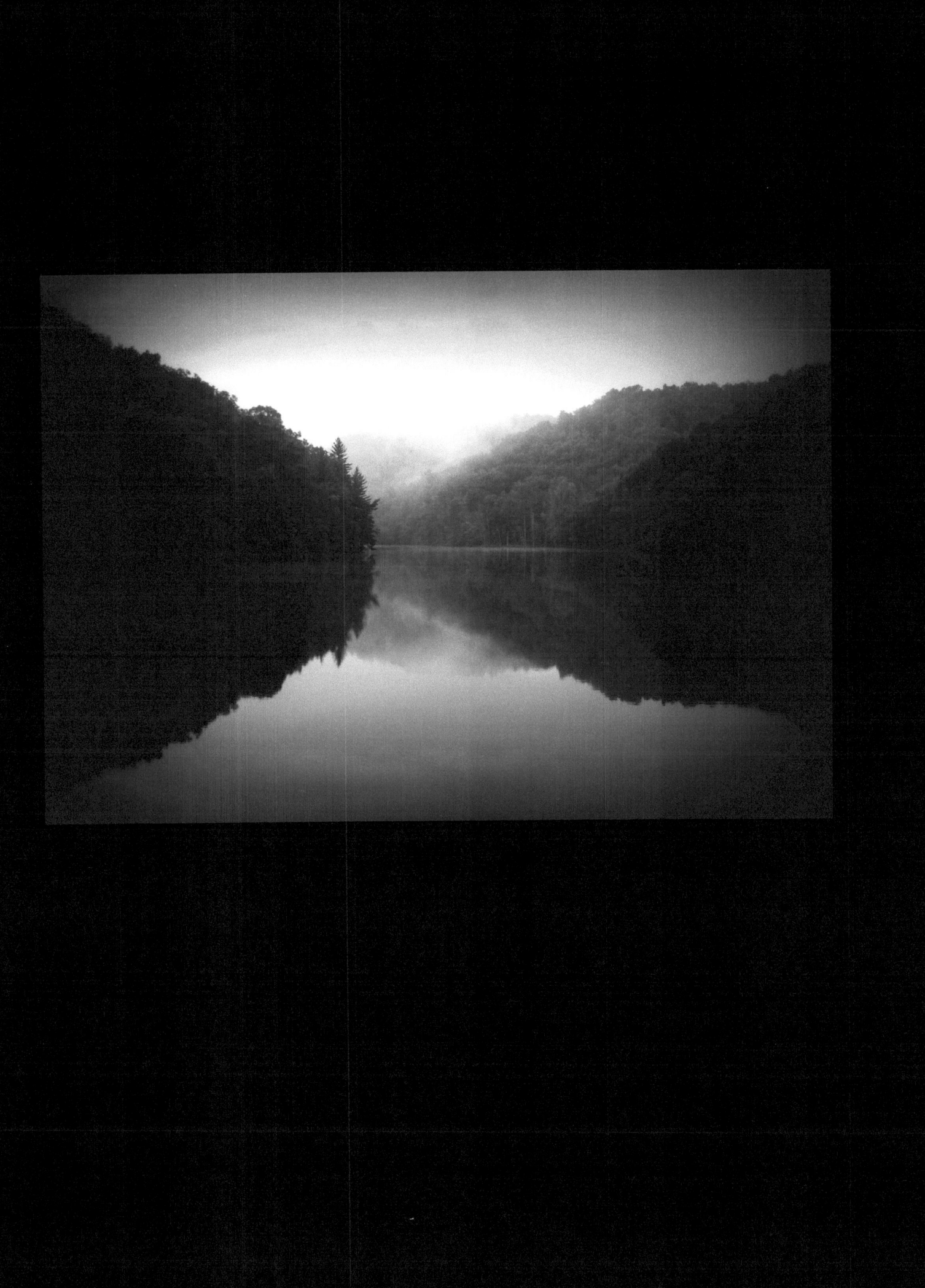

From the moment
You emerge
Others tell you
What to do
They try to
Set your direction
And decide
What is best
For you
They want you
To do things
Their way
So you follow
To avoid
Their wrath
However
The finest way
To grow
Into you
Is to always
Choose
Your own path

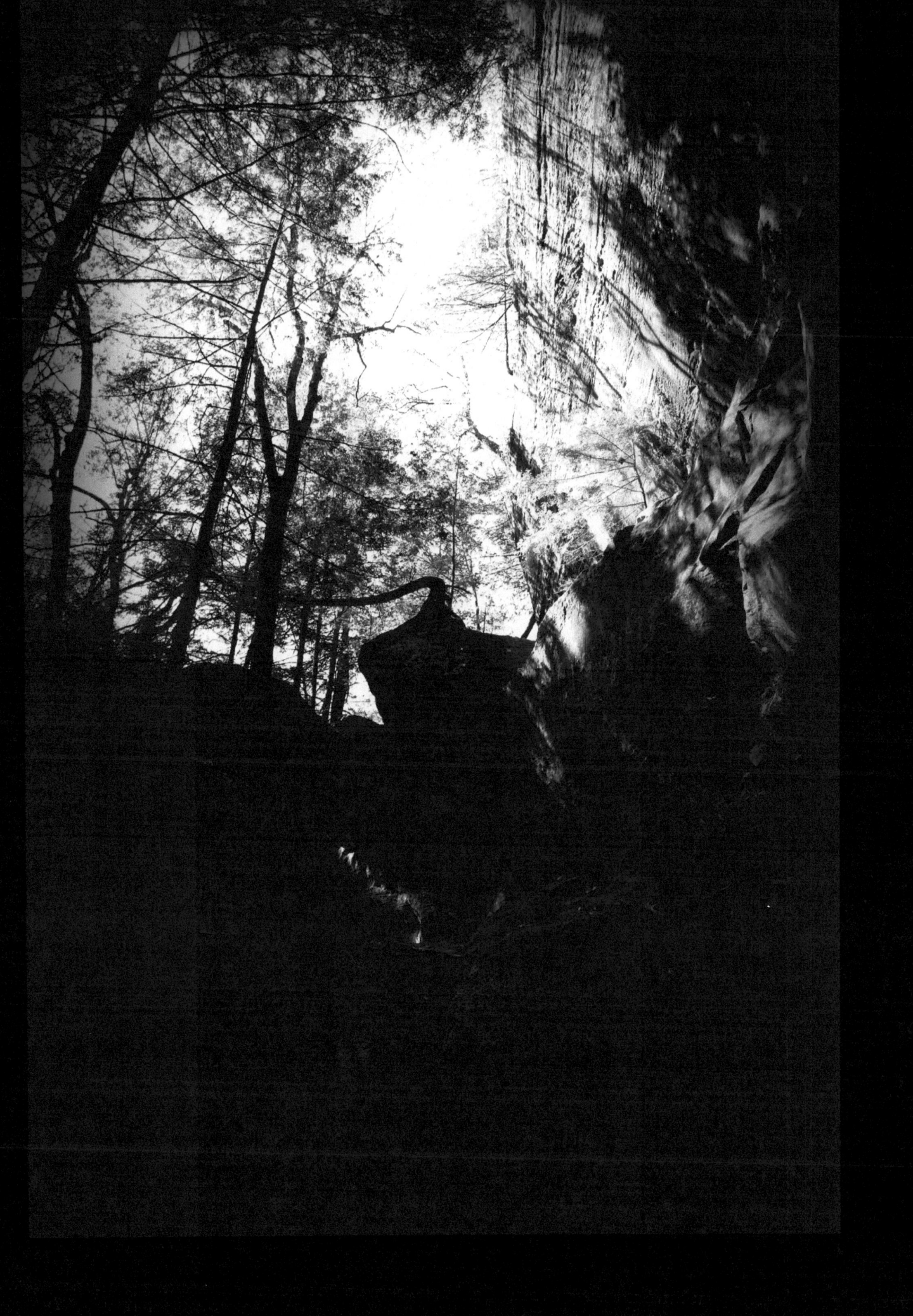

The silence
Was deafening
As darkness
Roared my way
It started off
So ordinary
Like any other
Day
Sometime between
Then and now
I lost my
Will to stay
I had once been
So full
Of life
But that passion
Has grown bleak
So I must
Sigh
My last
Goodbye
As I rest
In final
Sleep

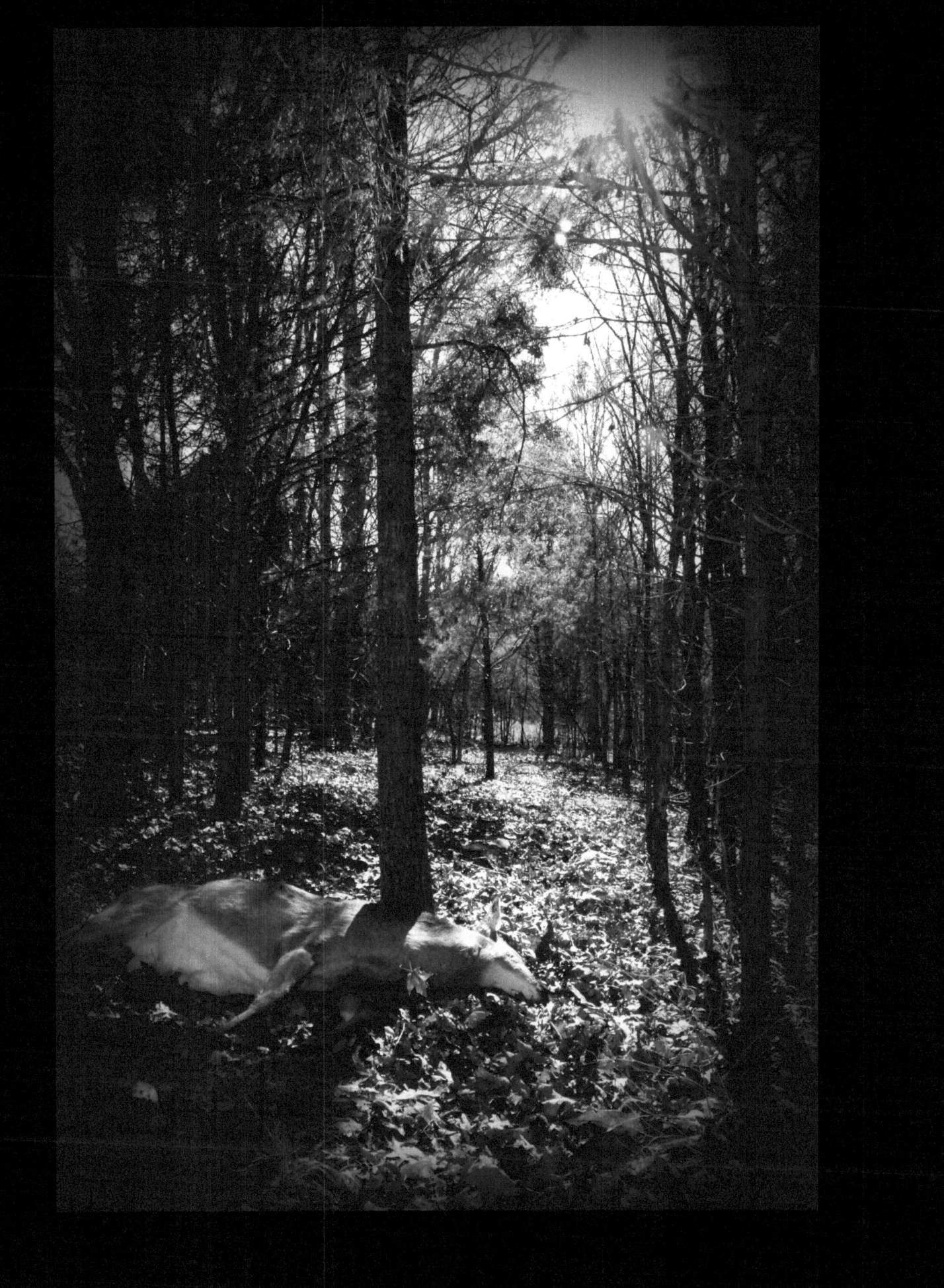

Broke
Distraught
Feeling maniacal
Moments of hope
Are soon viewed
As denial
There must be
A way out
But I cannot
Reach the light
Visions of
The future
Are appearing
Less than bright
I have dealt
With this
Before
But cannot
Remember when
It is now
Time for me
To become
My very own
Best friend

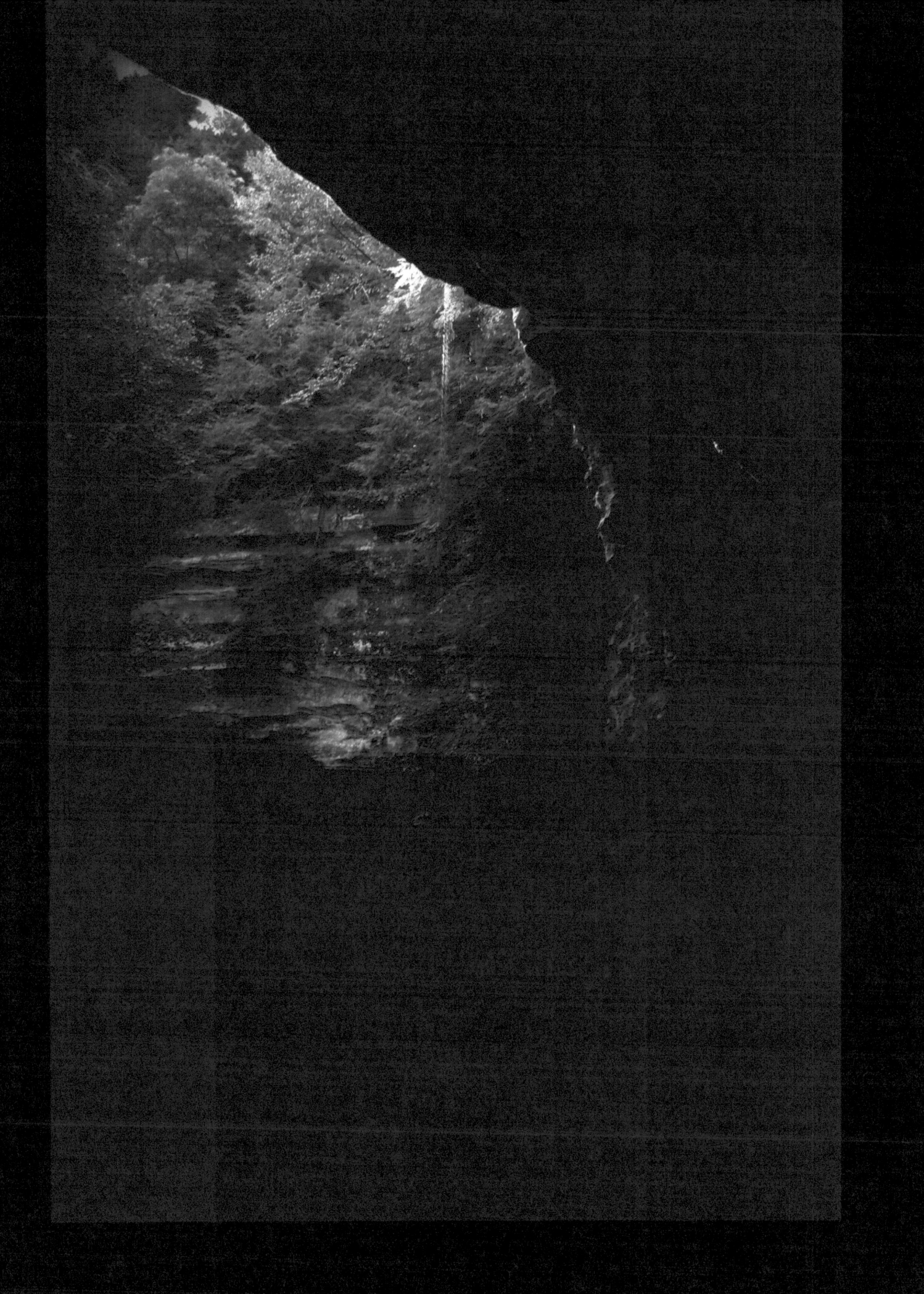

The bane of
Every writer
The ominous
Blank page
The inability
To get the
Feelings out
Leaves the blockage
Entangled
With rage
Darkness illuminates
The mind
And the thoughts
All misbehave
While searching
For a glimmer
Of light
To help translate
The etchings
In the cave

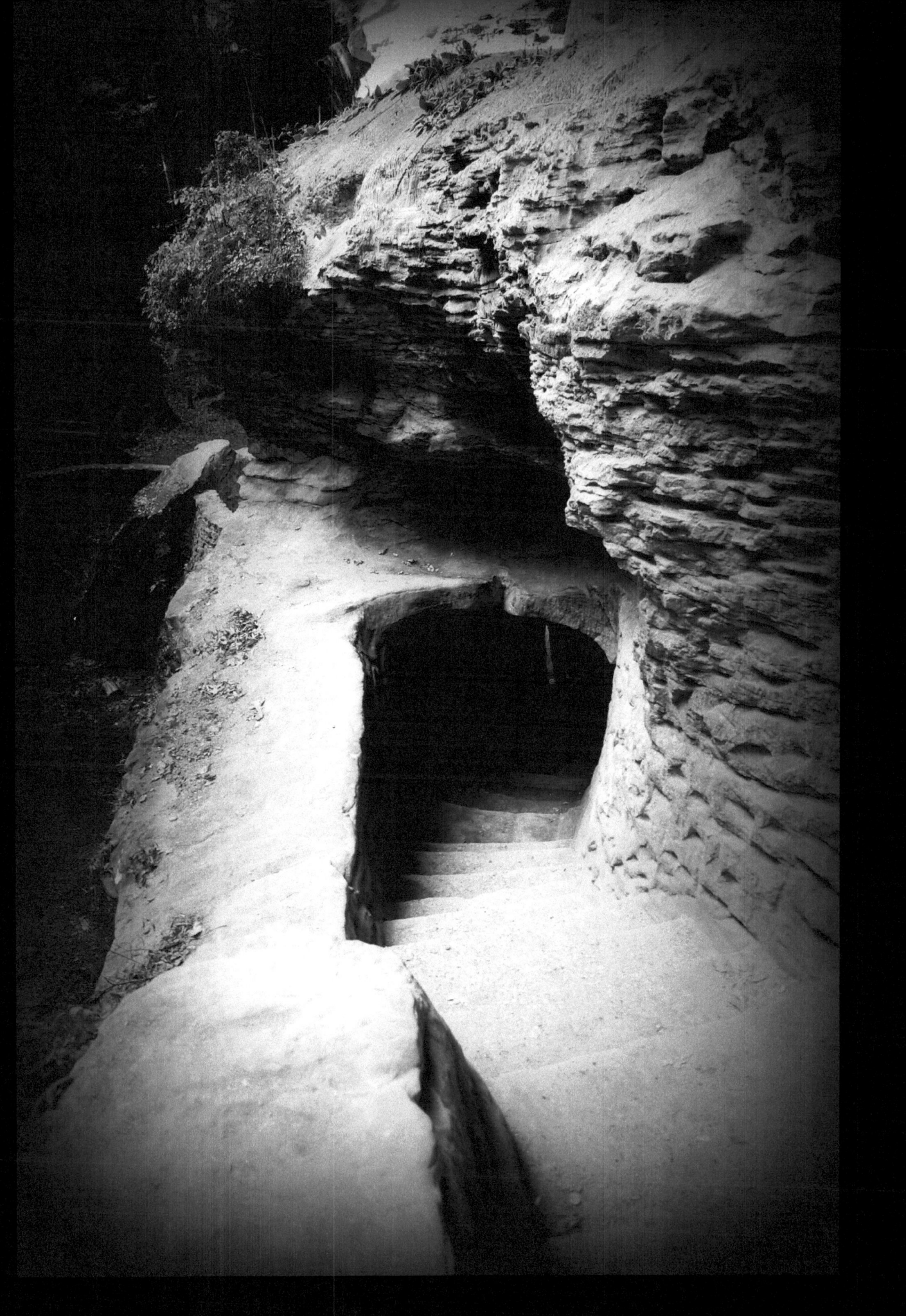

I've spent
Too much time
Inside of myself
Focused on
Remaining
Self centered
And keeping
Everyone out
I drew
The blinds
And peaked out
From behind
As life
Went on
Its way
While I
Have not fully
Emerged
From that hole
At least
The black
Has lightened
To grey

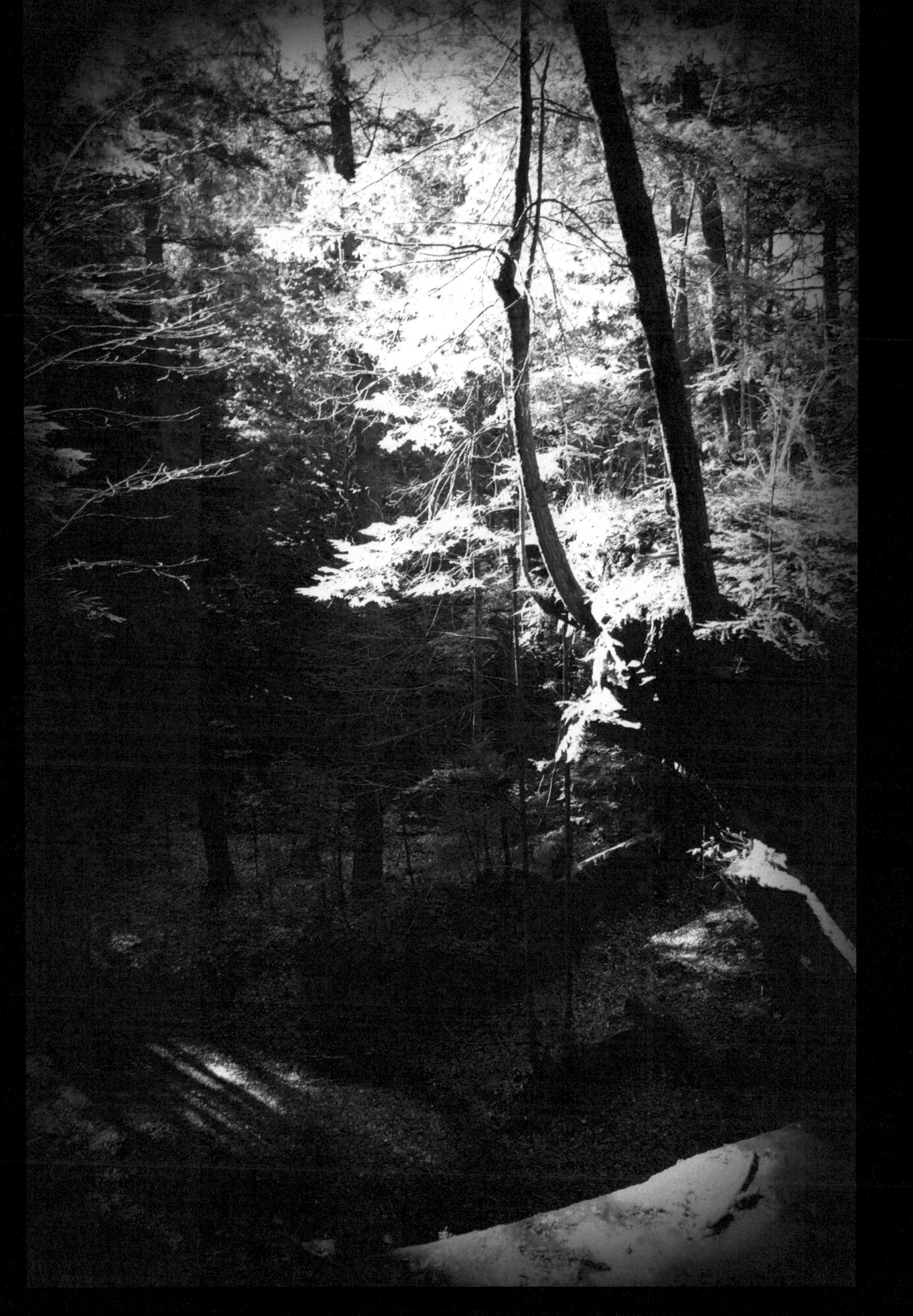

You felt like
You never mattered
That your life
Has been a
Mistake
No one ever
Noticed you
And it's become
More than
You can take
But you are
Done
Being invisible
And are now
Something
That others
Should see
There has to
Be a way
To ignite
Your light
From a spark
Maybe they won't
Get to
Know you
But at least
You'd have left
Your mark

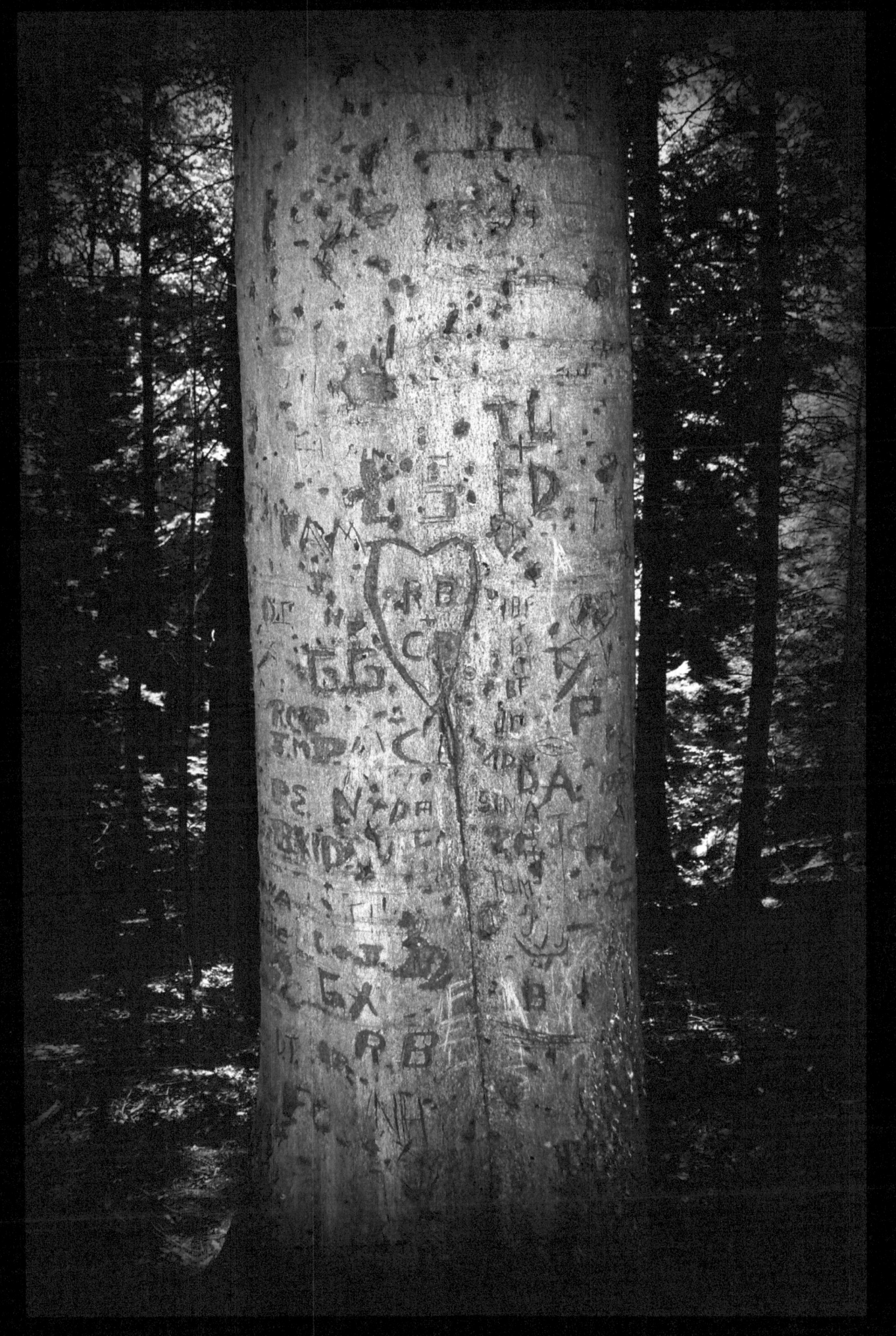

It is such
A shame
That I grew up
So late
For someone
Without faith
I left an
Awful lot
To fate
Wrestling with
Myself
In an endless
Internal debate
I was told
That who
You dream of
Is someone
That you wanted
To see
That is why
I find it
Confusing
That I never
Dreamed
About me

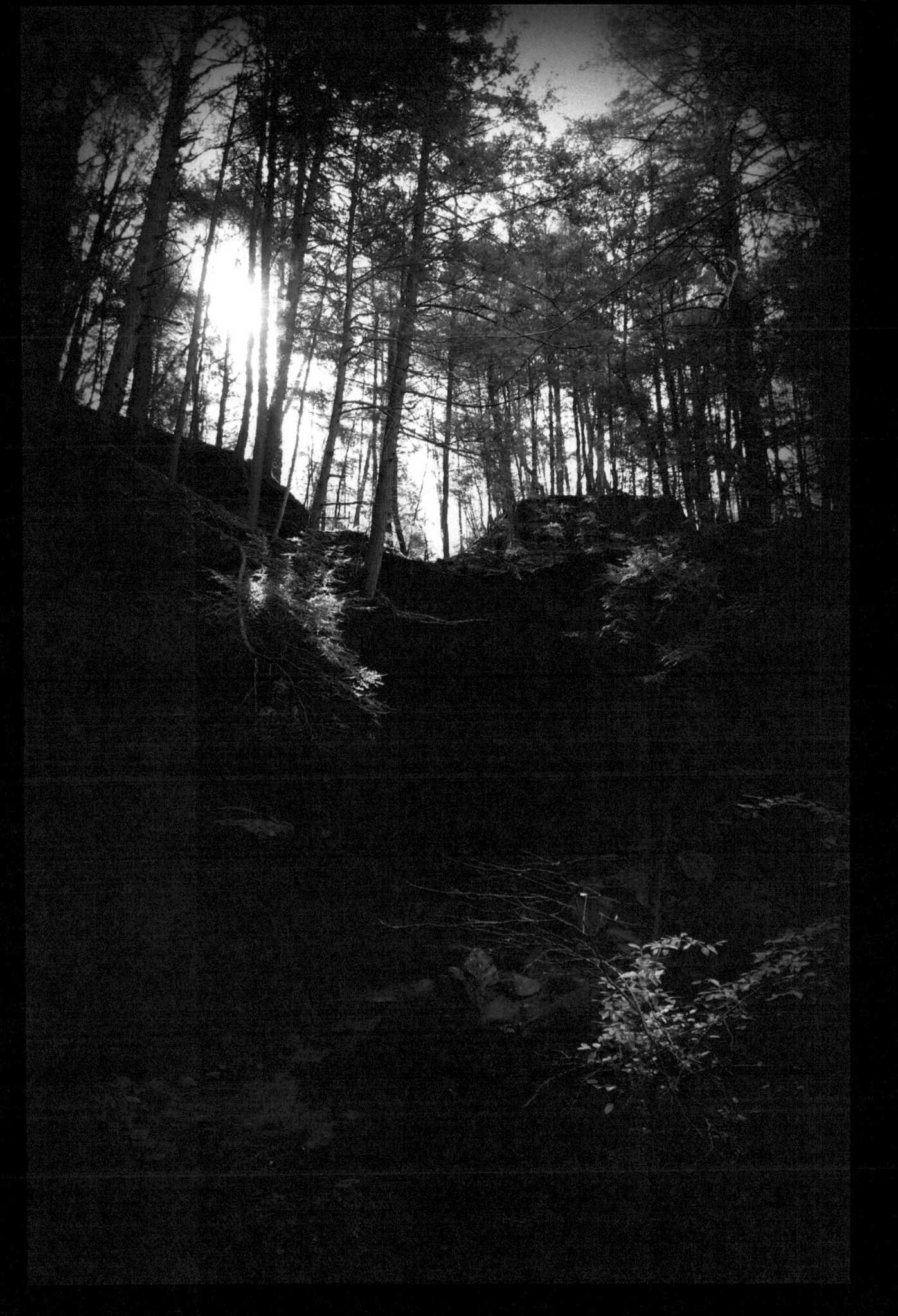

Traveling these
Passages
Reminds me of
Once upon
A time
And how what
I saw then
As perfect
Now hardly
Defines divine
Confronting embraces
From counterfeit friends
I thought these
Memories
Would someday
Fade away
But some things
Refuse
To become
Pretend

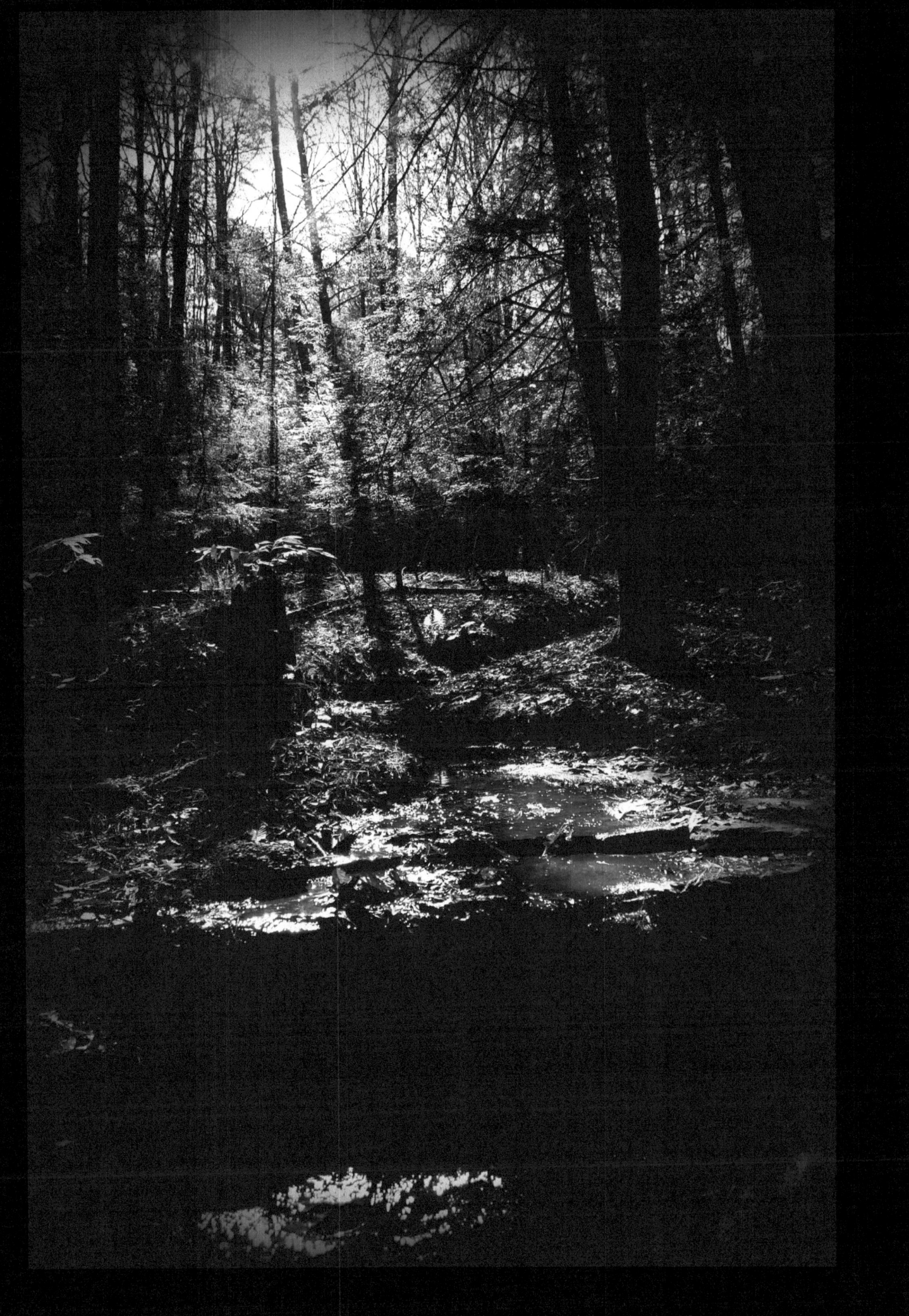

It seems like
Forever
But it was not
That long ago
When the thought
Of holding you
Was all
I needed
To know
How did the
Comfort
Of your embrace
Somehow disappear
The image
Of our love
Used to shine
So clear
Now it's hard
To find
I fear
It must be
Hiding
In the shadows
Of my mind

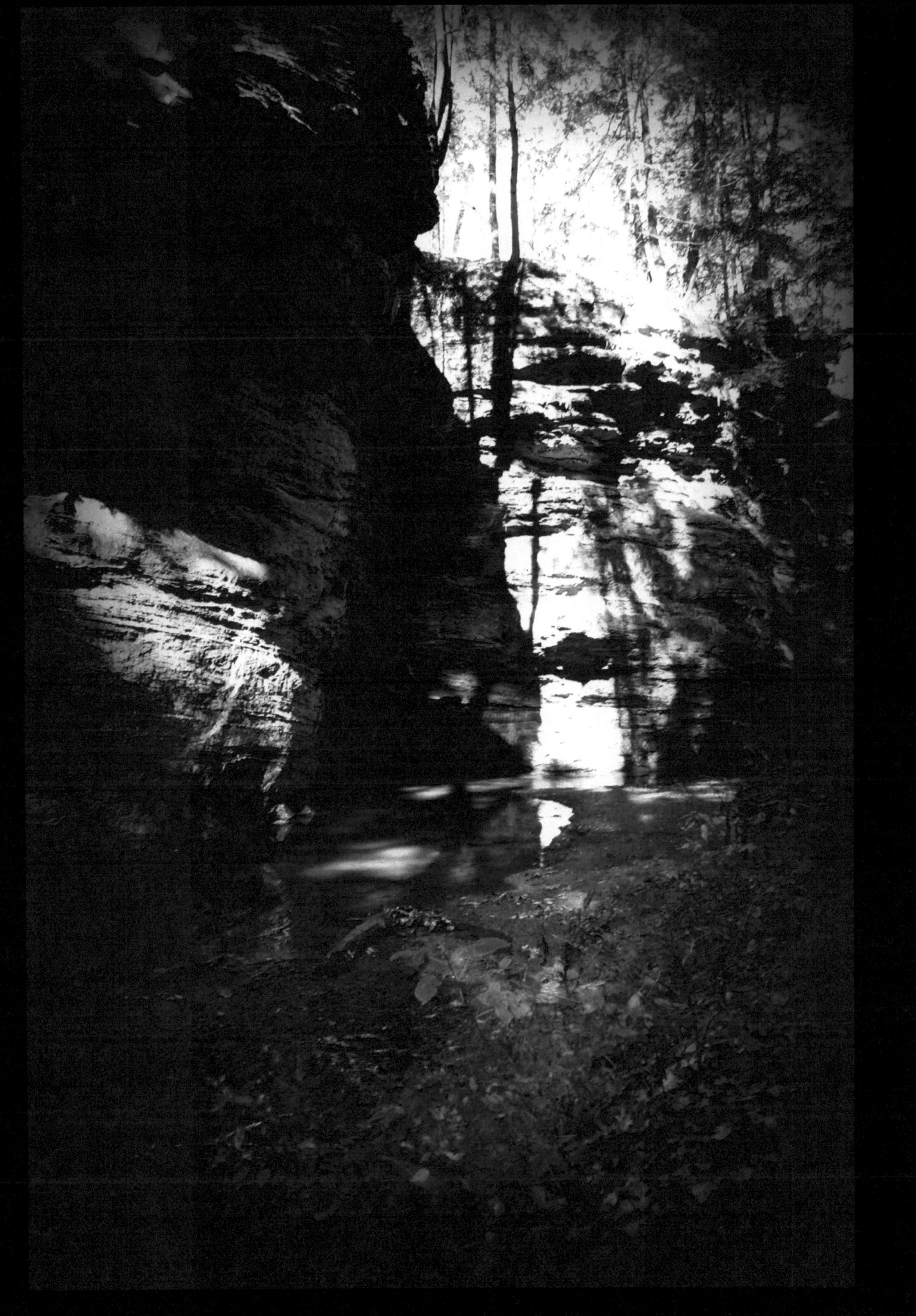

We started off
Far apart
But were heading
In the same
Direction
Things seemed
Similar enough
I thought maybe
We could form
A connection
Thru many twists
And turns
Our seperate journey
Appears to be
Done
As we now
Merge together
And two paths
Finally
Become one

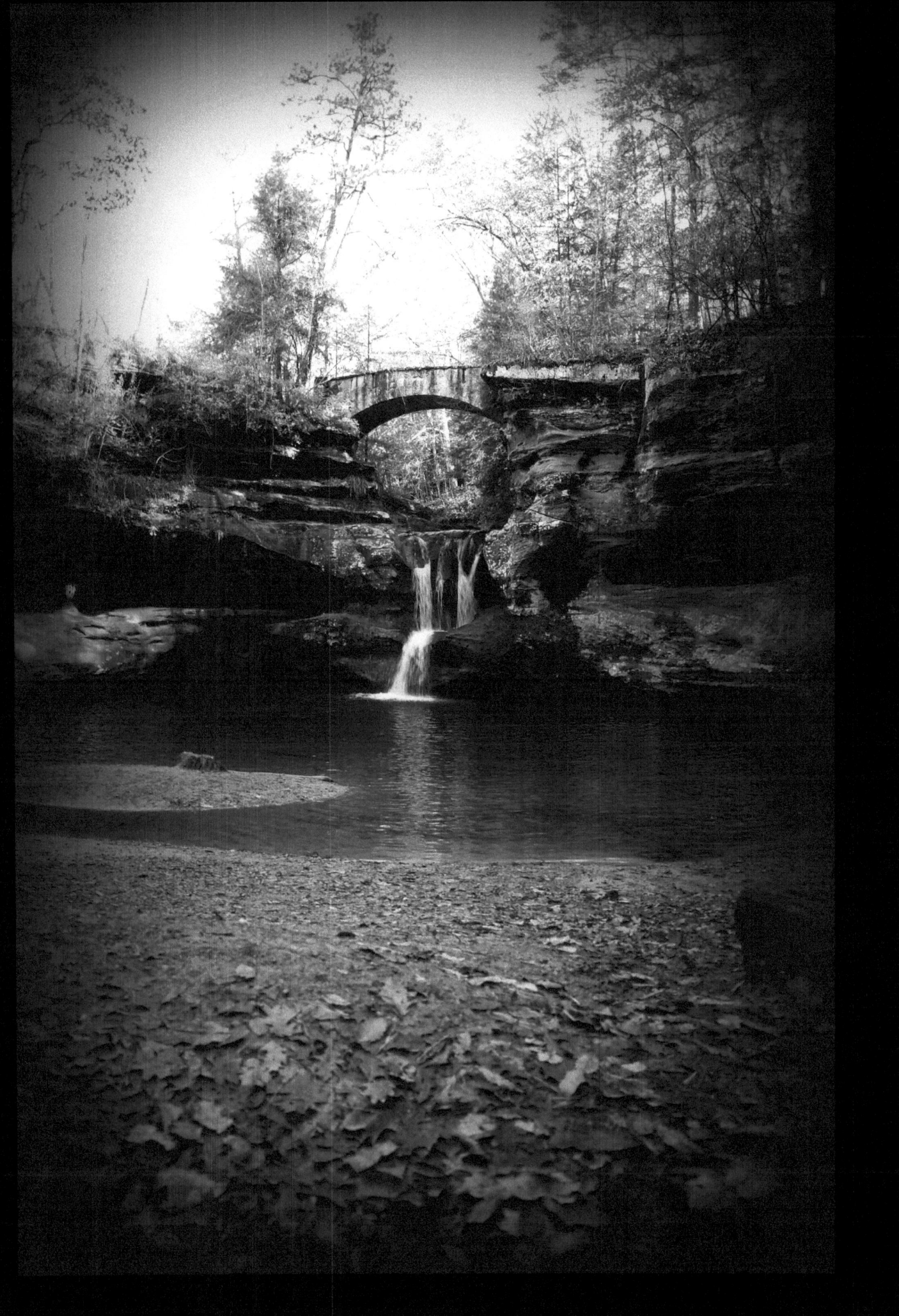

I'm not trying
To mislead you
Or make my
Promises
Merely words
That I said
I understand
That you realize
These dreams
Are just thoughts
That I have
In my head
I do hope
You give me
The time
To prove that
I'm more than
Some guy
I may not
Look like
Much now
But someday
I promise
I'll fly

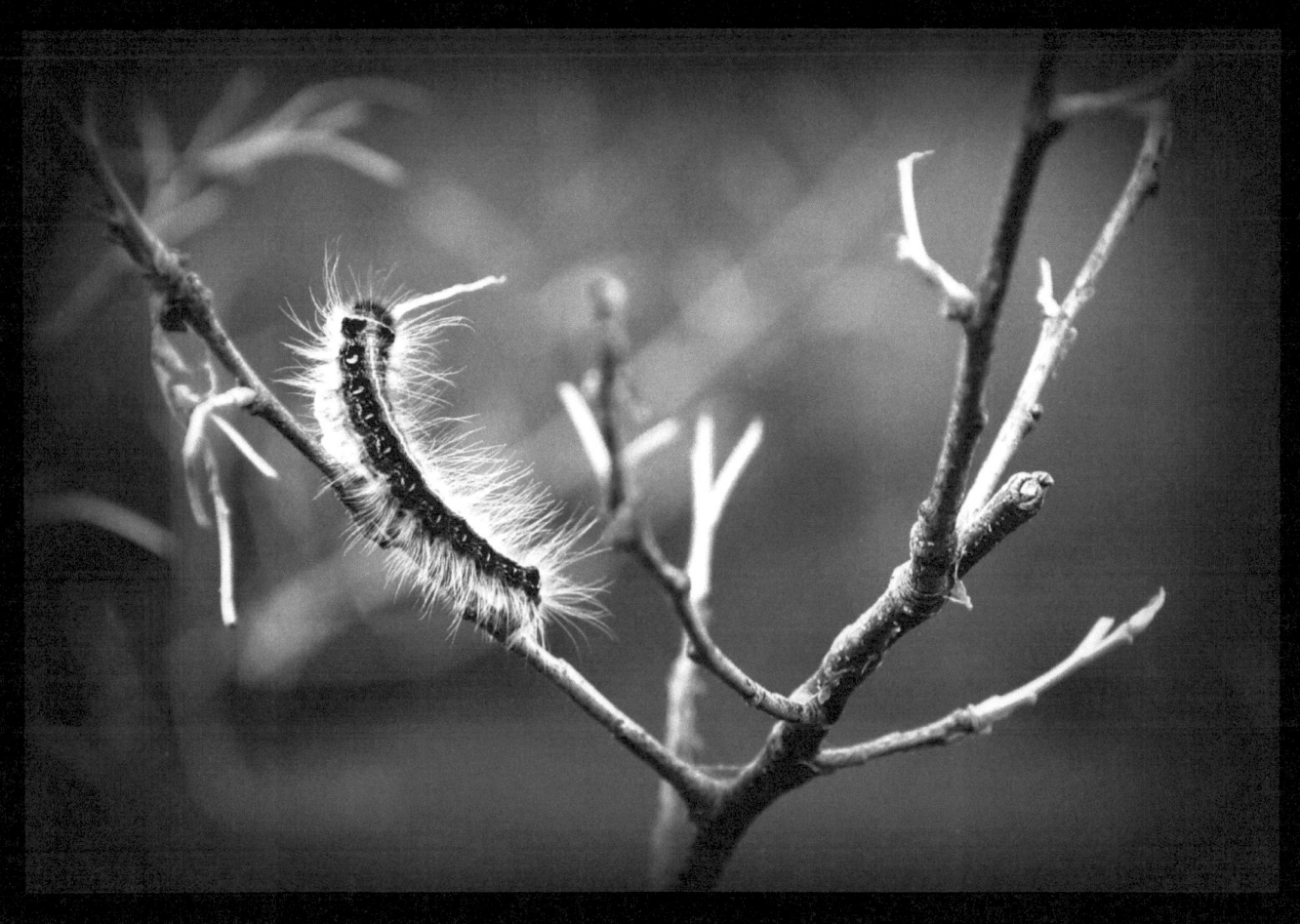

Faith
I met her
Once
Seemed like a
Pleasant lass
Her memory
Still lingers
But never
Actually lasts
Sometimes I think
That she's
Right here
A presence
I love
To feel
Other times
I question
If her
Existence
Was ever
Even real

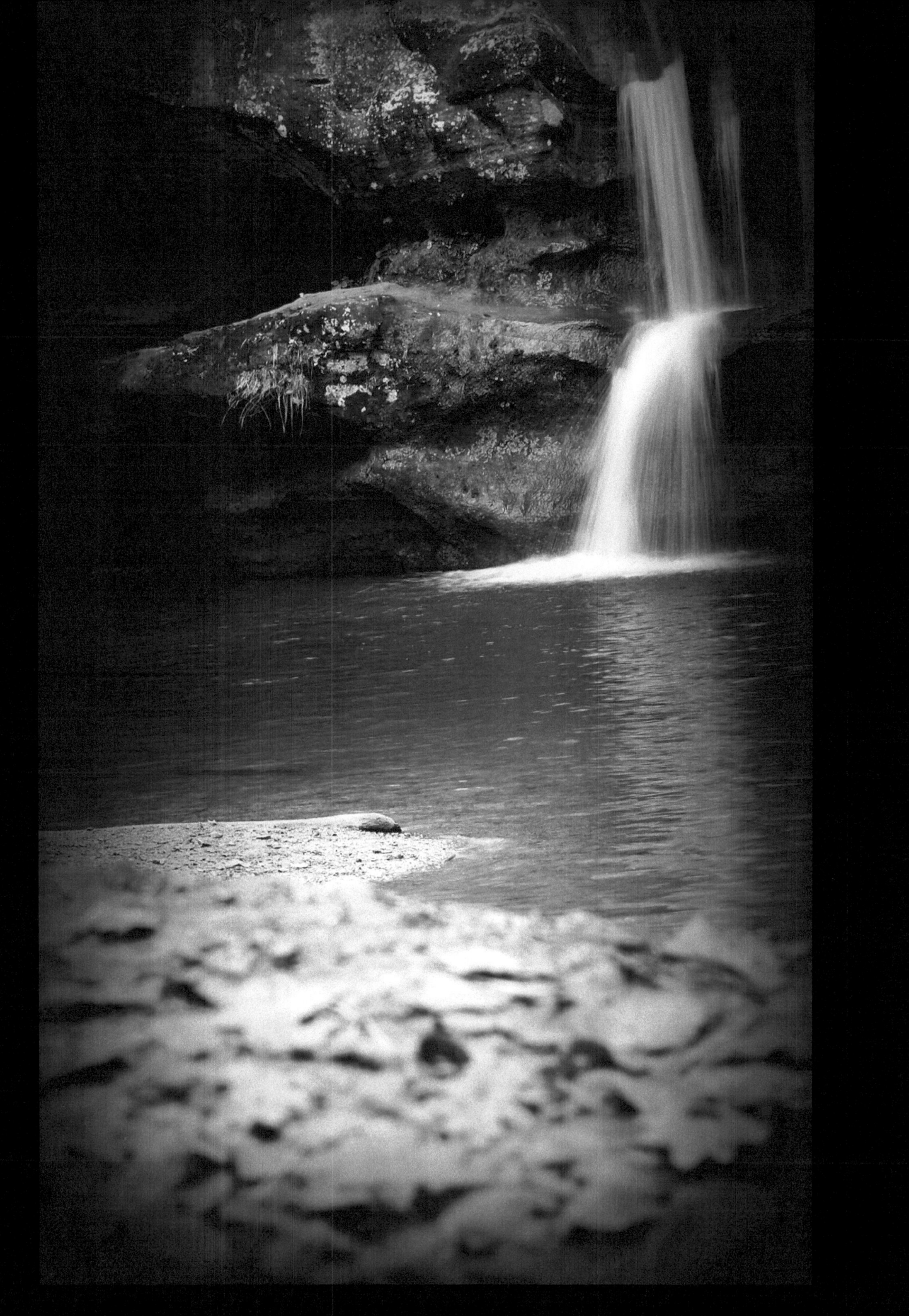

It is our
Endless search
That can feel
Like an
Impossible dream
The satisfaction that
Never leaves us
And gives our hearts
A permanent
Gleam
If it is something
You think exists
Chances are you
Are probably wrong
It is simply
A fact that
You know
And reminds you
Of angels
In song
We try to
Capture amazing
And create a
Merger that flows
It's like trying
To catch
The wind
Then hold it
And never
Let go

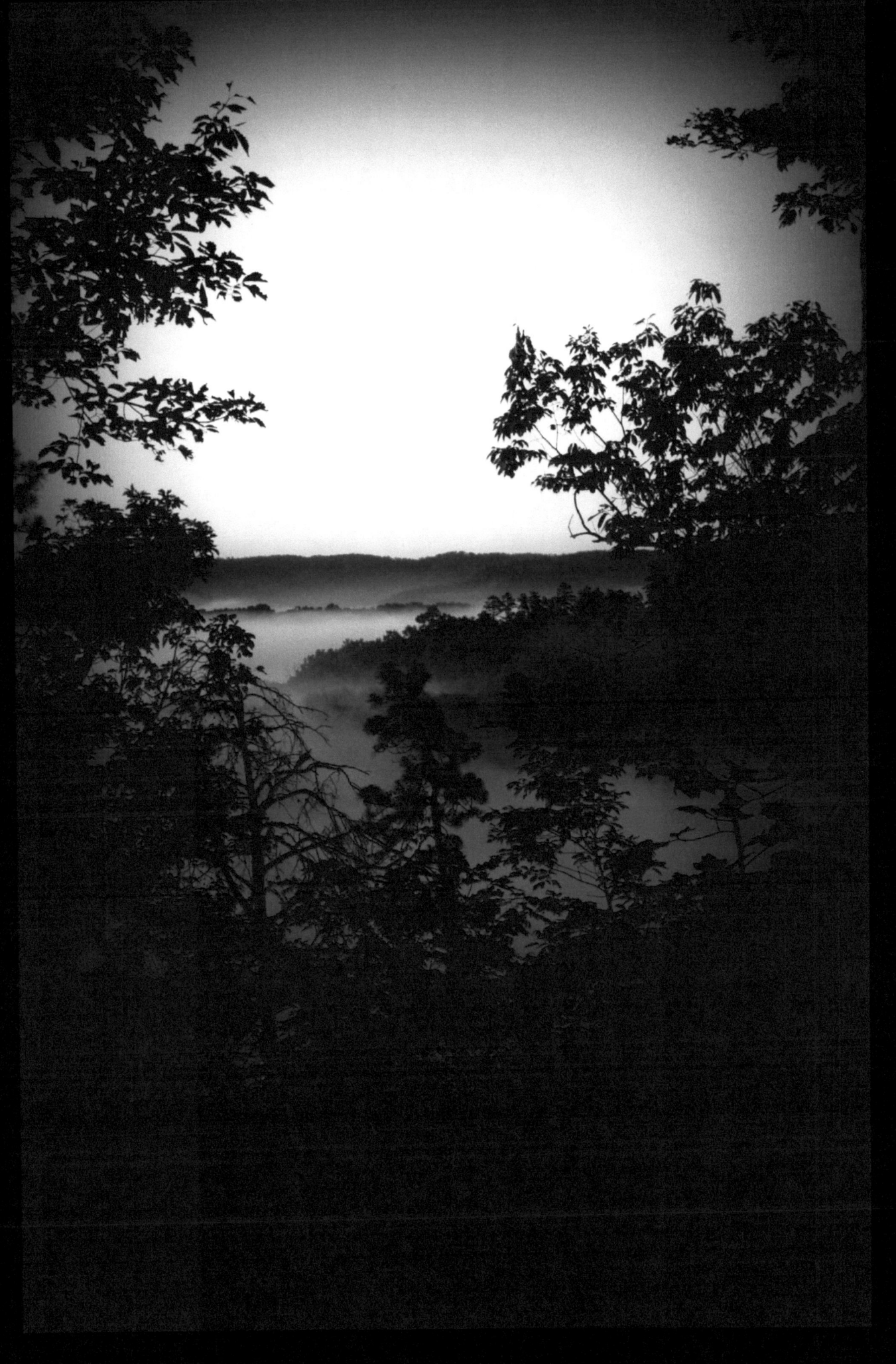

When I try
To explain
Our relationship
Others never
Seem to get
What I say
No matter what
Words I use
They all kinda
Hear it
Their way
Even though I
Say things
Quite clearly
They reach their
Conclusions
Too soon
So they don't
Understand
How I'm feeling
But then again
They have not
Seen you
In bloom

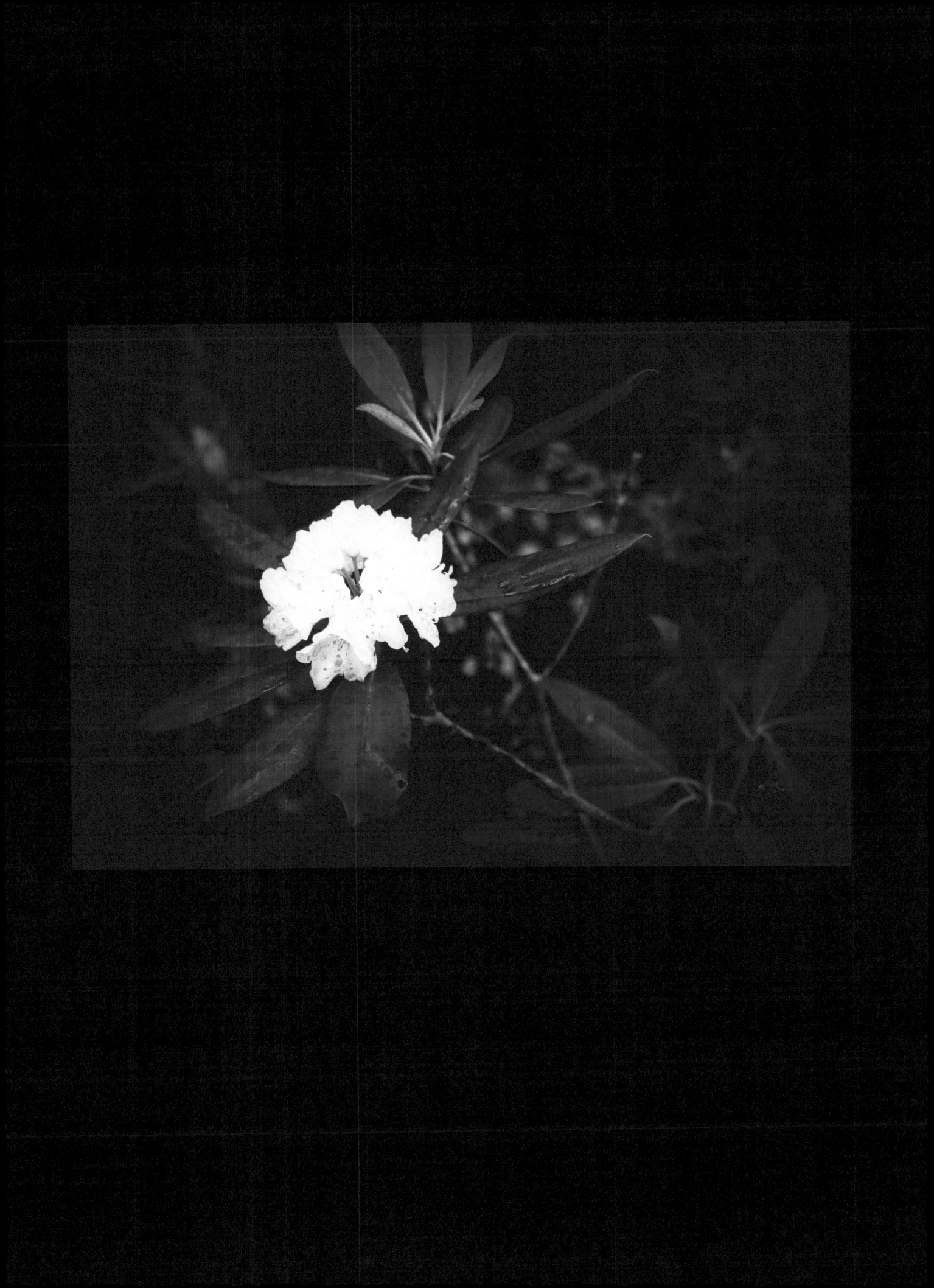

It almost seems
Defective
Though it beats
Just fine
Past loves have
Left some damage
To this old
Heart of mine
I know it
Was not you
That left it
Battered
And bruised
I can truly
Only offer it
As is
Which is not
Gently used
Although your
Angel kisses
Refurbish it to
Almost new
Trespass at
Your own risk
It's not yet
Fully open
To you

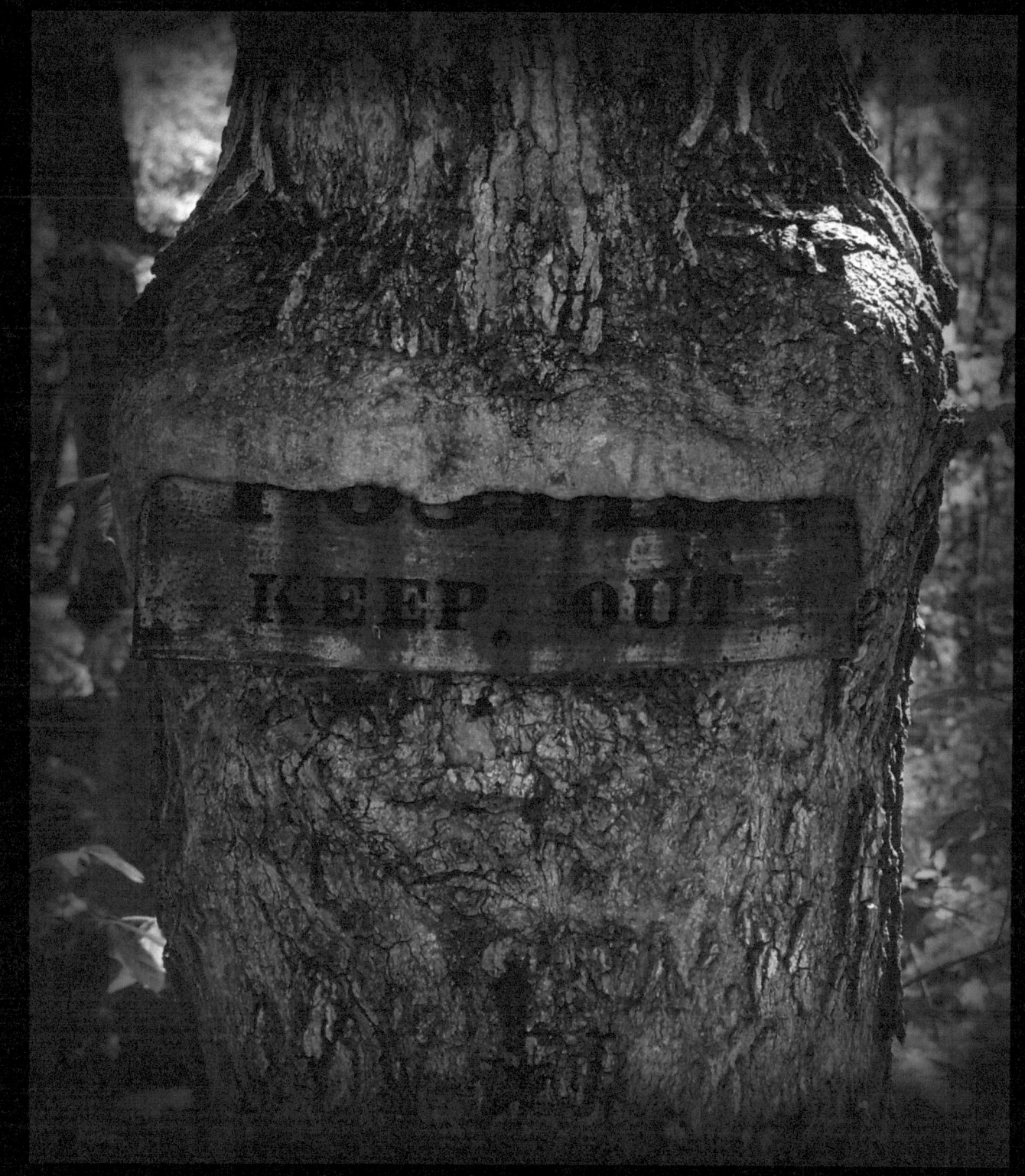

The incision
You made
Left an
Indelible scar
I want to
Forget you
But you
Never
Get far
The memories
Of forgotten times
Hold me back
With what
I left
Behind
You act
As though
You are
Disposable
But you are
Truly
Not that
Kind
All I want
Is to find
A way
To get you
Off
My mind

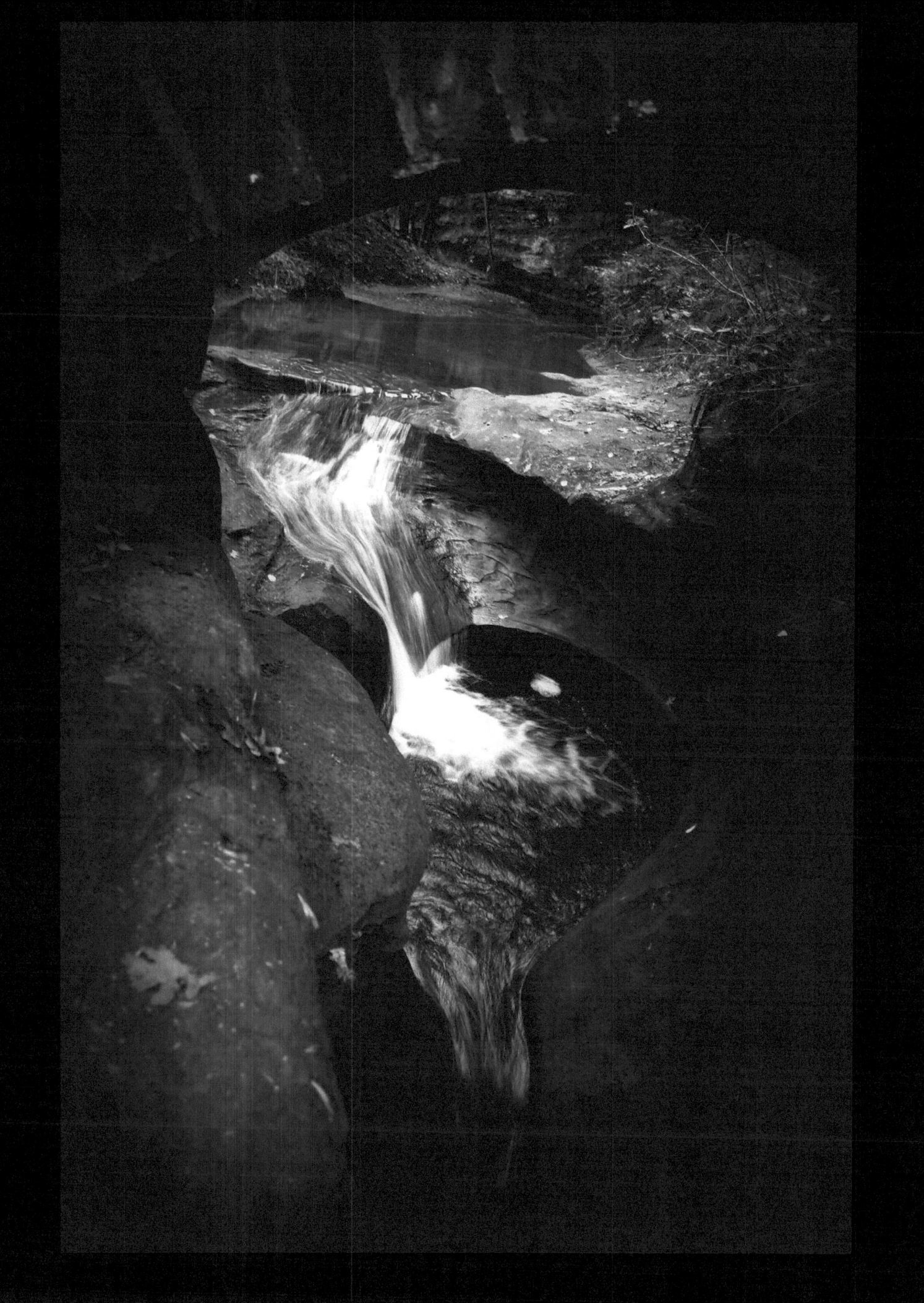

I know that
You watch out
For me
And you have
The best
Of intention
Although it seems
Like every
Move I make
Requires your
Intervention
I understand
It's done
With love
And it's just
My back
You're covering
But it appears
From my
Point of view
What you're doing
Is more
Like smothering

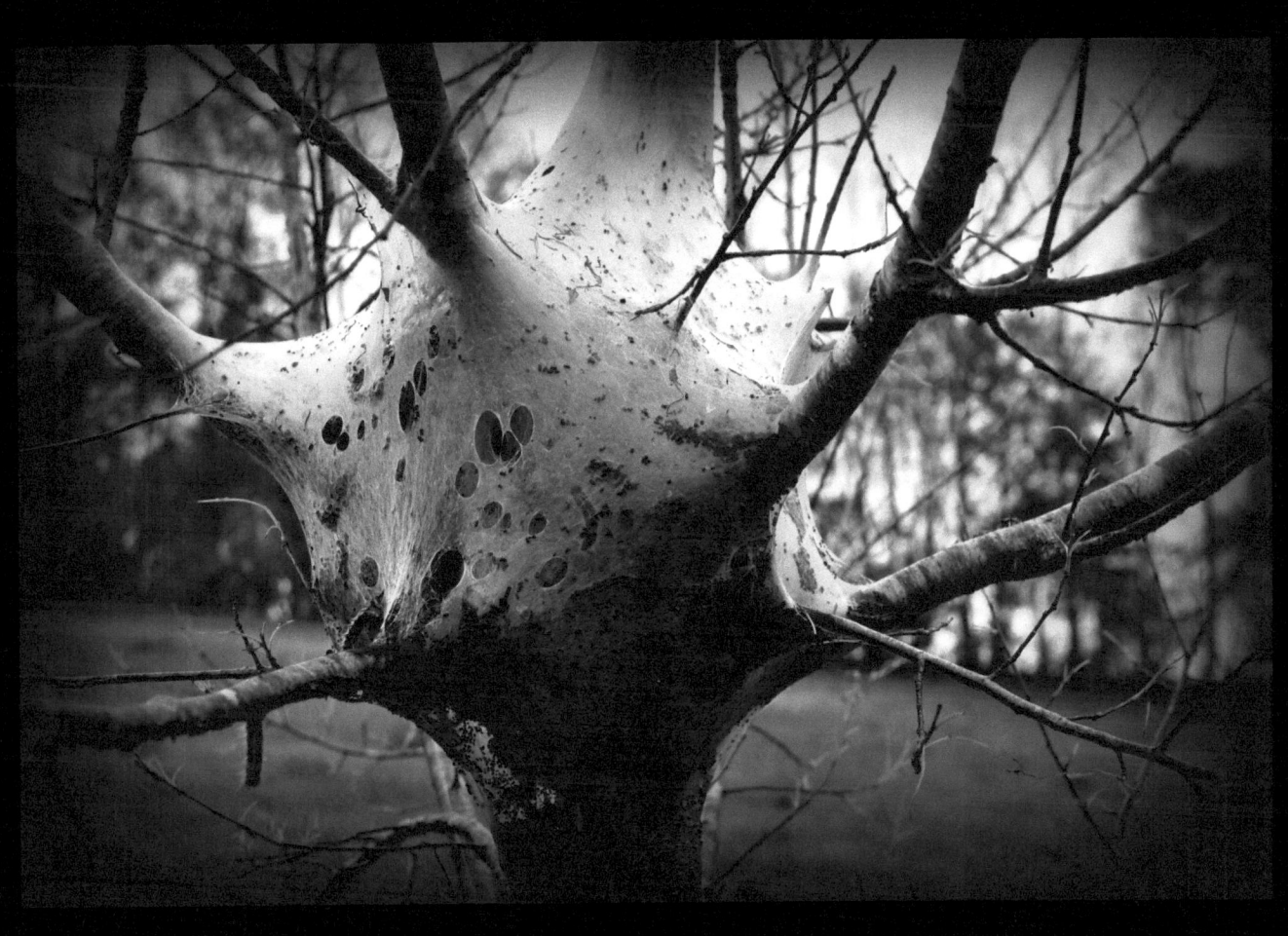

We acknowledge
Your qualifications
And understand
What you desire
To do
But where we see
Our future
Does not seem
To fit
With you
There is something
That they just
Don't see
How I will grow
And change
They are simply
Narrow minded
And feel things
Will always
Be the same
I accept their
Poor decision
While holding
Faith
In what
I can do
If you don't
Believe
In magic
It can never
Believe
In you

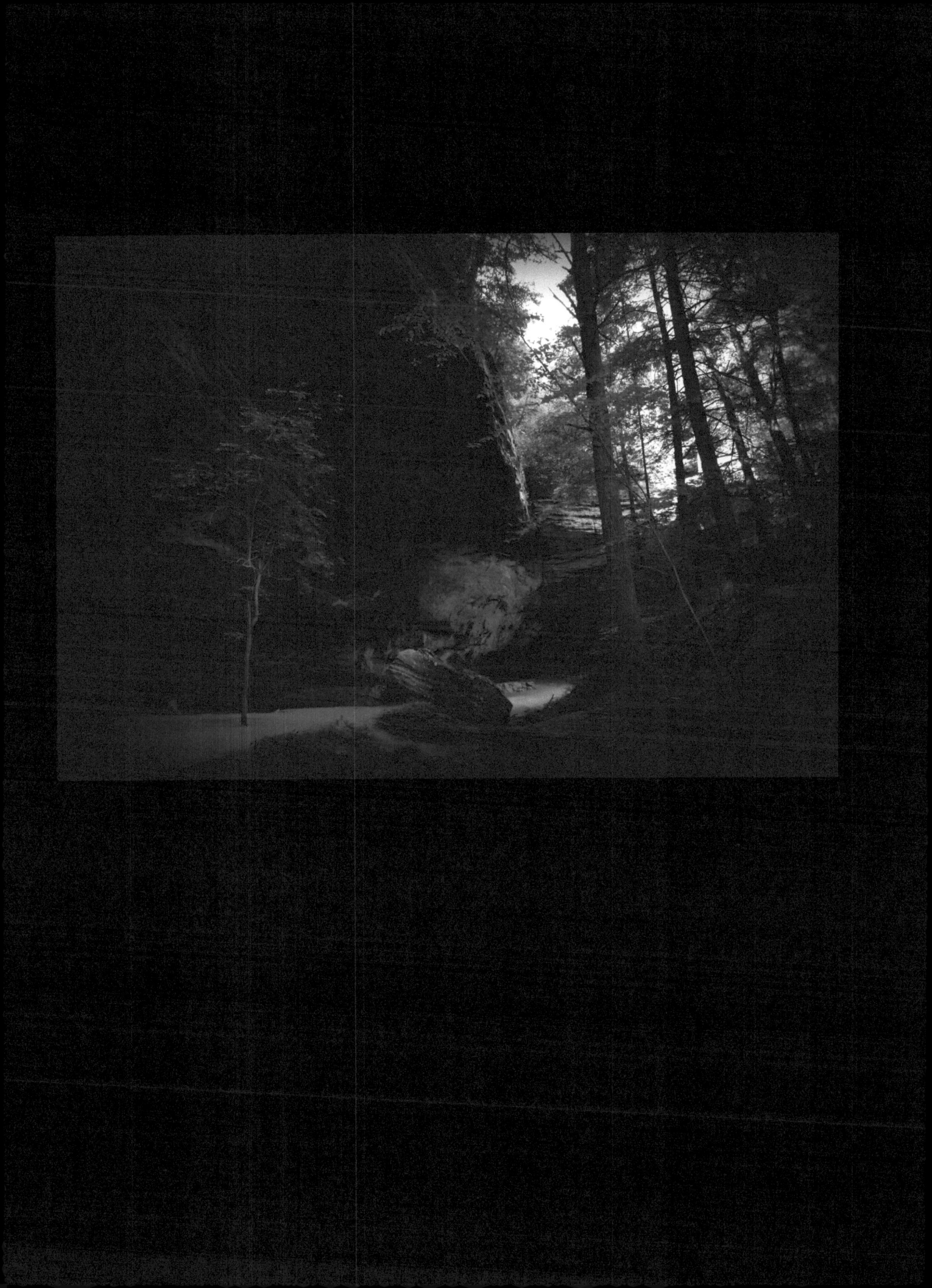

When you say
I love you
I have
A twinge
Of fear
Is that something
That's felt
All the time
Or only
When I'm near
Feelings that
They say grow
Fonder
May sometimes
Disappear
When the heart
Is out
Of view
Its vision can
Grow unclear
Though your words
May in fact
Be true
They are not
Sensed sincere
Or have
The doubts
My mind contains
Gone beyond
Severe

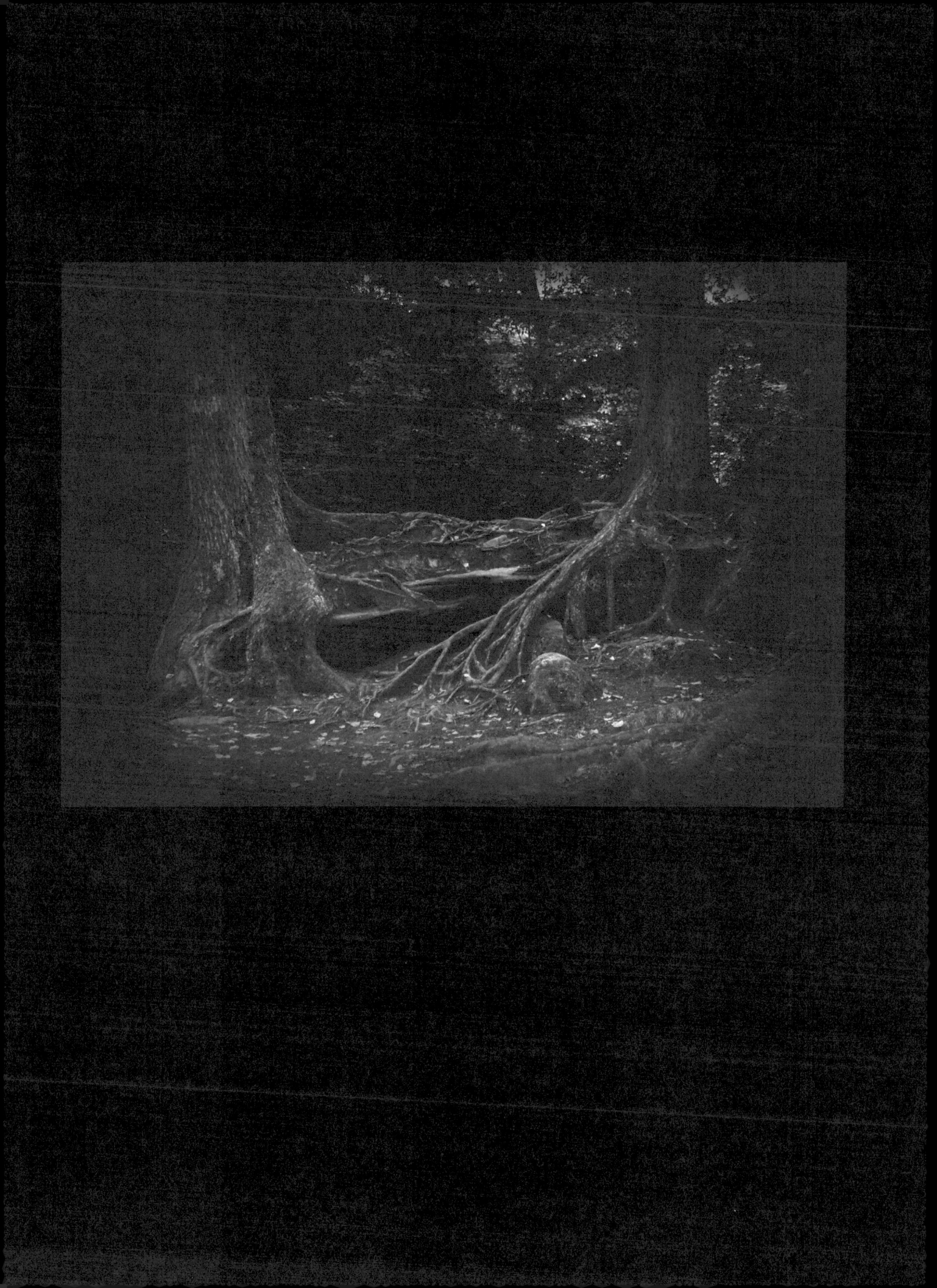

They thought
I was thinking
About leaving
But that idea
Seems truly
Absurd
Though they
Appeared to
Have been listening
I guess it
Was something
Else
That they heard
They understood
That part of me
Had a crash
And that pieces
Ended up
Making a splash
But missed that
When I emerged
From the darkness
I found
A light shone
On my path

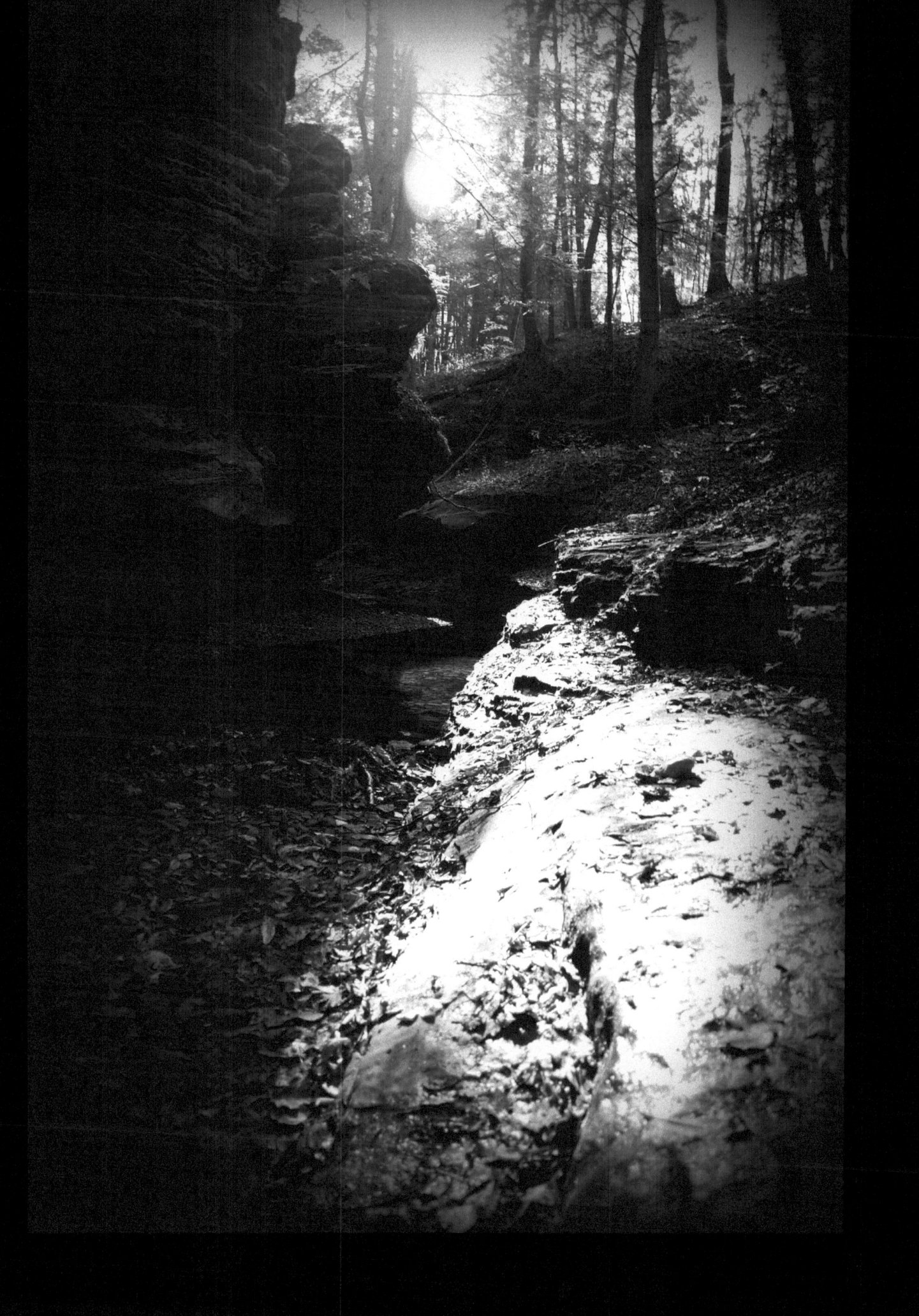

It emerges
As a thought
That grows to
An idea
A vision of
What you wish
To create
Now begins to
Become clear
You can see
Your goal
And understand
Your roll
And so now
Your work
Can start
The dream of
Every artist
Is when life
Becomes
The art

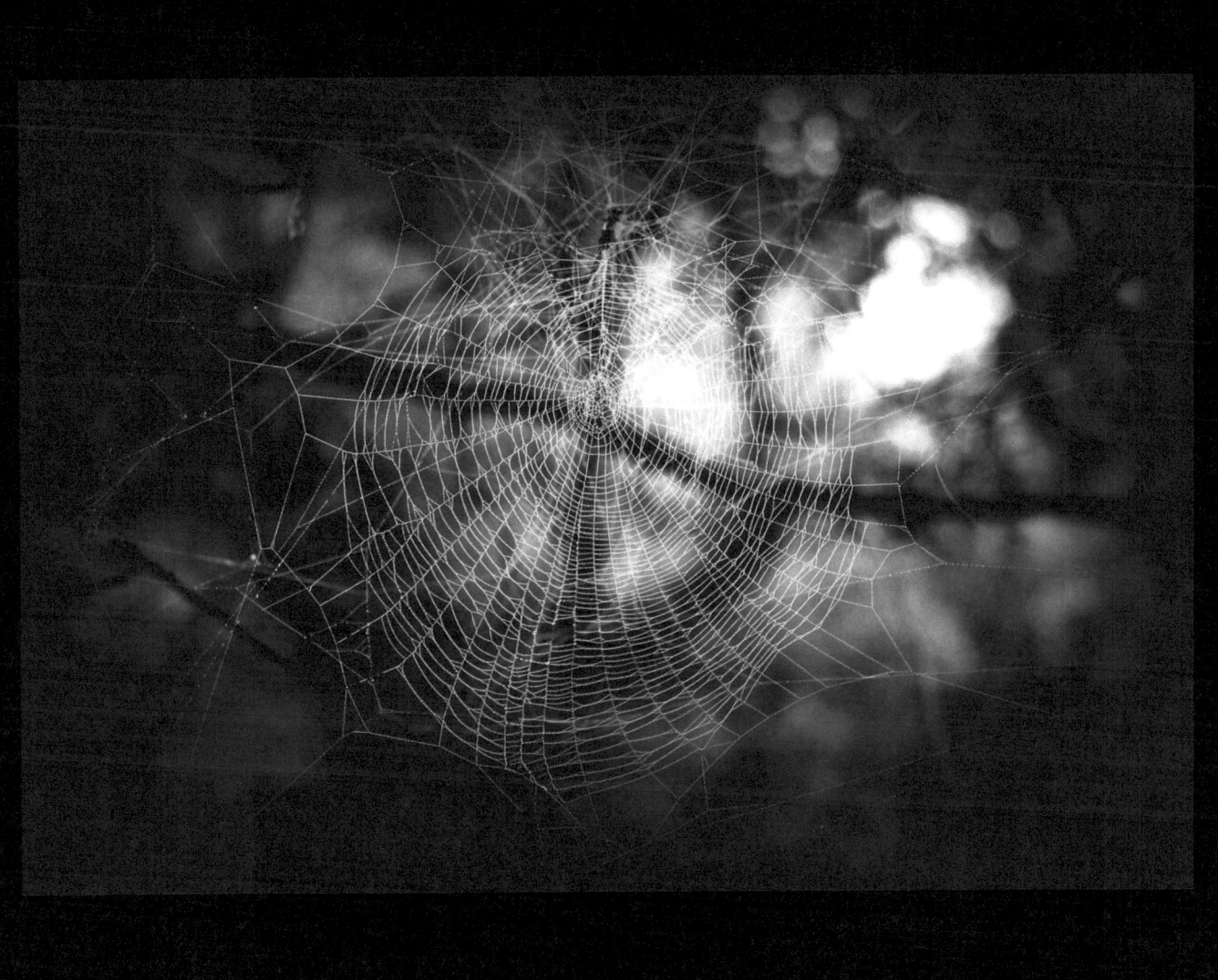

I remember what
Has happened
Things may never
Be the same
But there is
No use
In living backwards
And trying
To give it
A name
The past
Has passed
Time has moved on
Perhaps a chance
To change things
My way
The beginning
Of every dream
Starts with a
Brand new day

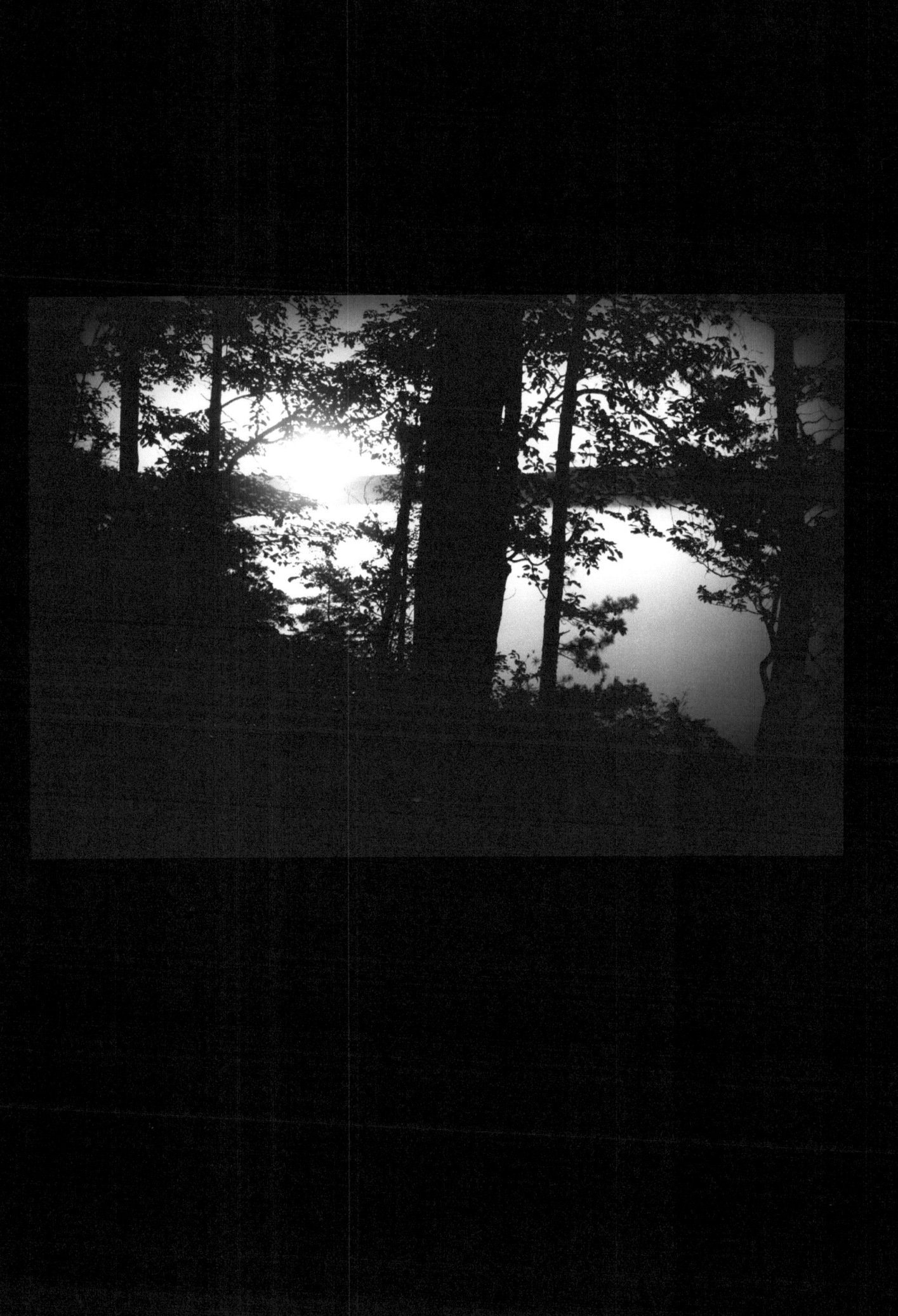

It feels like
A while
Since I've shared
A clear thought
With someone
Outside me
I've challenged
And fought
Making me
My worst enemy
Which is not
A wise
Thing to do
I place myself
At the bottom
Then got used
To the view
This has made me
My burden
And left my mind
Confused
I need to
Forgive me
And get past
All that stuff
As from where
I now stand
The only way
To go
Is up

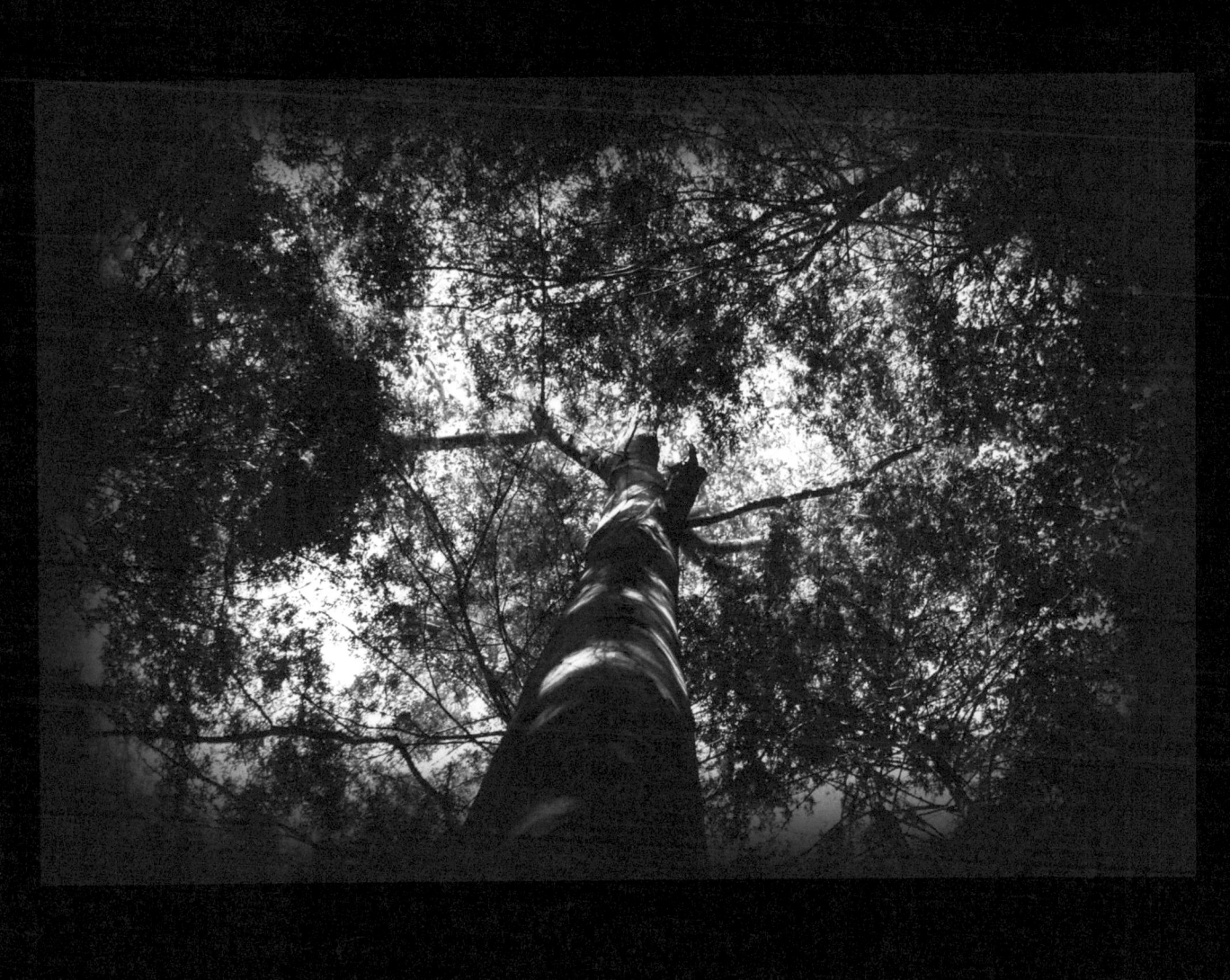

A moment spent
On introspection
Shuffle thru
My brain's collection
Of pack rat thoughts
Better thrown away
While dusting off
The ones
I can still
Use today
The mirror
Does not offer
A reflection
It shows more
Of a direction
A path
I have not
Seen before
Just off
The cliff
There is a
Door
That leads to
Points unknown
To survive
This dive
I must rely
On strength
I've never
Shown

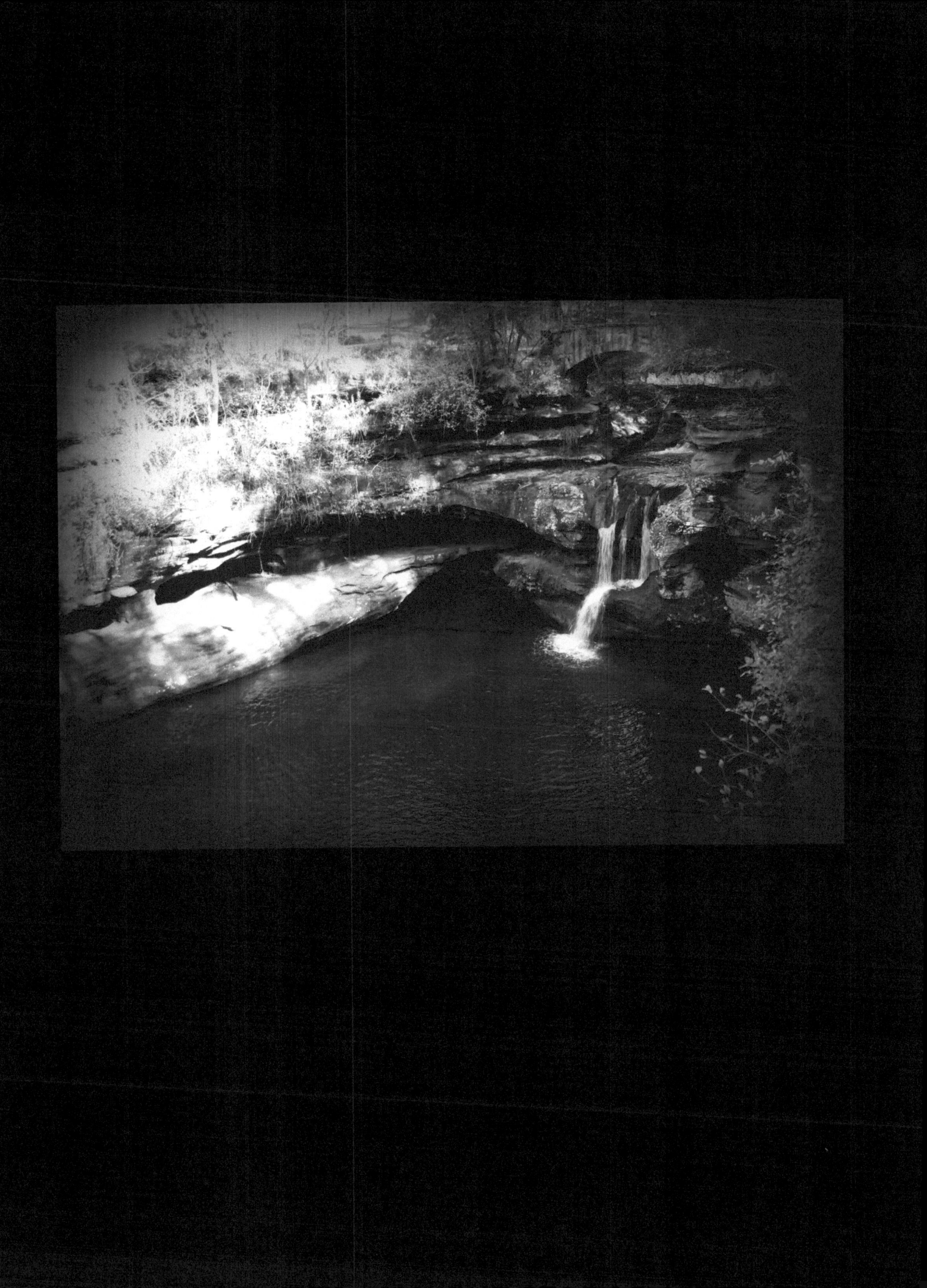

Reverend Joe is an ordained and licensed minister who currently resides in Newport, Kentucky. His writing is inspired by anything, everything, and, on occasion, seemingly nothing. He believes there is a rhythm that flows throughout existence, and when he is able to catch the wave, he then applies some lyrics.

Emily Florence is an artist based in Cincinnati, Ohio. She received her bachelors in art from Morehead State University, and her Masters of Fine Arts from the University of Cincinnati. These photographs were taken in the forests of Central Ohio, and Daniel Boone National Forest in Eastern Kentucky, the place she calls home

www.ingramcontent.com/pod-product-compliance
Lightning Source LLC
Chambersburg PA
CBHW051052180526
45172CB00002B/612